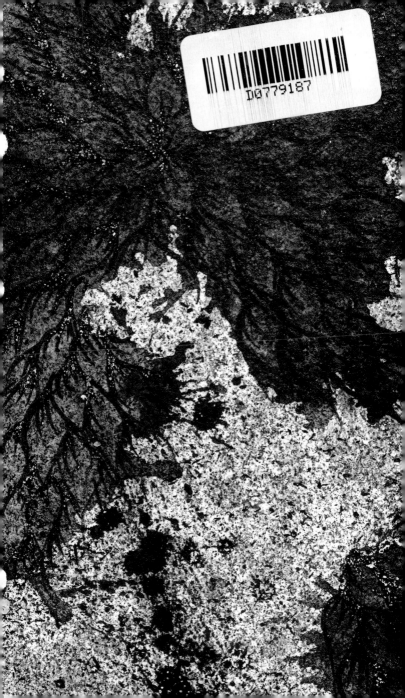

The Roof Garden Commission

Imran Qureshi

Ian Alteveer

Navina Najat Haidar

Sheena Wagstaff

The Metropolitan Museum of Art, New York

Distributed by Yale University Press,
New Haven and London

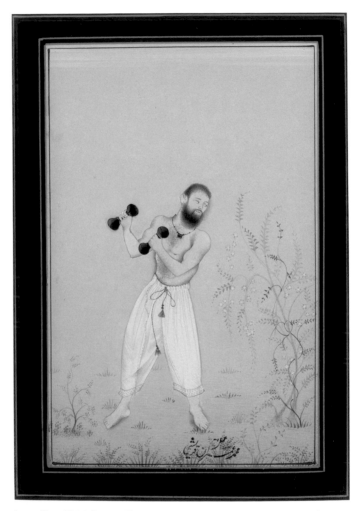

Imran Qureshi. *Moderate Enlightenment*, 2006. Gouache on paper, 7 7/8 × 5 1/4 in. (20 × 13.5 cm). Courtesy the artist and Corvi-Mora, London

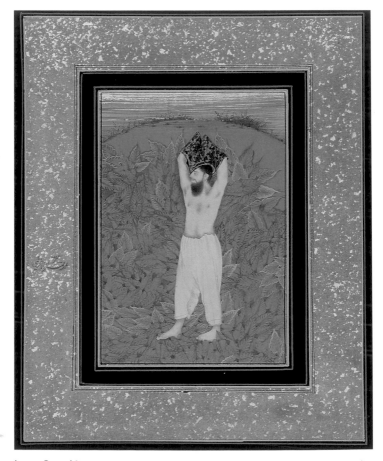

Imran Qureshi. *Moderate Enlightenment*, 2009. Gouache and gold on paper, 11 ¼ × 9 ¼ in. (28.5 × 23.5 cm). Courtesy the artist and Corvi-Mora, London

Sponsor's Statement

Since 2007, Bloomberg has been the annual corporate sponsor for the Met's Iris and B. Gerald Cantor Roof Garden projects, and we are pleased that this year's installation by Imran Qureshi reflects Bloomberg's long-standing interest in supporting the work of visual and performing artists across the globe. Qureshi's site-specific work is particularly powerful overlooking Central Park, which provides a unique backdrop for the artist's rich, colorful imagery.

Every day, Bloomberg connects influential decision makers to a dynamic network of information, people, and ideas. With more than 15,000 employees in 192 locations, Bloomberg delivers business and financial information, news, and insight around the world. This dedication to ideas is also demonstrated in our global commitment to artistic excellence, emerging and pioneering works, and expanded access to diverse cultural opportunities. Our worldwide partnerships with visual, performing, and literary arts organizations strive to enlighten, engage, and educate the broadest possible public while promoting exploration for all audiences.

Bloomberg

Imran Qureshi in his studio, ca. 2010

Director's Foreword

I **am often told by artists** that the Metropolitan is their favorite museum. They mine our collections not only for inspiration, but also to understand the potency that allows five thousand years of artistic heritage to remain relevant in our modern world.

As the steward of this vast visual history, the Met is uniquely positioned to explore the work of contemporary artists who use tradition as one of their points of departure. Imran Qureshi is just such an artist. Steeped in the techniques used to create the great Mughal-period manuscripts, his work breathes new life into historical forms, poignantly connecting them to the social, political, and natural environments in which we now live.

The presentation of Qureshi's work on The Iris and B. Gerald Cantor Roof Garden signals a new perspective on this space and its potential. Sheena Wagstaff, our Leonard A. Lauder Chairman of Modern and Contemporary Art, has conceived of this project and publication as the first in a new series that will focus specifically on the significance and meaning of the site. Organized by Associate Curator Ian Alteveer, Qureshi's installation is immersive, using color and pattern to evoke a range of complex associations. The result is stunningly beautiful and deeply resonant.

We are grateful to Bloomberg for its consistent support of our Roof Garden projects. Without its generosity, we would not be able to pursue such innovative approaches to this singular space. We also thank Met Trustee Cynthia Hazen Polsky and her husband, Leon B. Polsky, for their important contribution to this project.

Thomas P. Campbell
Director
The Metropolitan Museum of Art

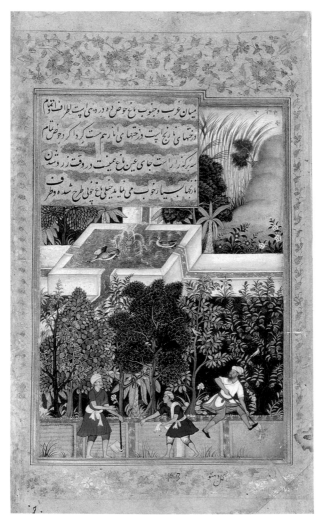

"The Gardens of Fidelity (*Bagh-i Vafa*) Being Laid Out at Kabul in 1504," Folio from a *Baburnama*, painting attributed to **Dhanu** (active ca. 1580–1600), India, 1590–93. Ink, opaque watercolor, and gold on paper. British Library, London (Or. 3714, ff.173v)

Another Kind of Dialogue

Sheena Wagstaff

A visit to Kabul, Afghanistan, is an encounter with a city of absorbing contradictions. While negotiating military checkpoints that bristle with armed personnel, wire-covered barricades, and sites of bomb-blasted masonry, one is simultaneously drawn to huge shiny billboards advertising mobile phones and cars or newly opened hypermarkets bedecked with strings of colored lights. Then, amid this teeming urban environment, one comes to a huge walled garden called Bagh-e Babur, the only green lung of the city.

 Lush with rosebushes, orange and nut trees, orchids, herbs, lawns, and a stream of water trickling steadily through a narrow stone channel sloping down its length, the recently restored "paradise garden" was originally created by Babur (reigned 1526–30), the first Mughal emperor, as a place for recreation and pleasure during his life as well as his last resting place. Overlooking the garden is the Queen's Palace, in which I first came upon the pale lapis-hued traces of a site-specific work by Pakistani artist Imran Qureshi (*Time Changes*, 2008, fig. 19; pp. 52–53). Responding to the movement of the sun through the windows over the course of a day, Qureshi's installation was defined by the shadows cast on the floor. He traced them at various intervals, then painted to the edge of their perimeters tiny blue geometric carpets of leaves, some of their edges faintly tipped with crimson as if they were turning into autumnal tones as light gradually diminishes from the day. Qureshi has described it as like a moving image, similar to a video, whose afterimage draws the visitor to the windows to look out on the Garden of Babur, teeming with Afghan families having picnics, university students on photographic assignments, or couples searching for a secluded romantic setting. Like a bucolic vision, an unlikely pastorale within a war-ravaged city, the view of the garden is linked inextricably with Qureshi's installation, which not only choreographs the visitor's experience of its setting, but also inspires her to expand her view and think twice about what she thinks she sees.

 Anticipating Central Park's treescape of bare branches thriving with the spring warmth into a dense canopy of leaves, Qureshi, in developing the work, has observed its analogy with a Mughal garden. The latter's trees and flowers are rendered in exquisite exactitude within the type of miniature painting that flourished in the

11

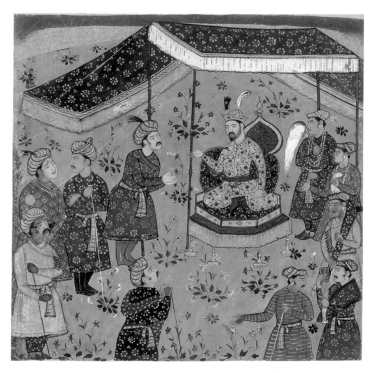

Reception of a Persian Ambassador by a Mughal Prince, early 17th century. Opaque water-color and gold on paper, 5 11/16 × 5 11/16 in. (14.5 × 14.5 cm). The Metropolitan Museum of Art, New York, Anonymous Gift, 1974 (1974.370.10)

Mughal era—in whose art Qureshi is trained. Like Bagh-e Babur, Central Park is a major urban public space, a vital and integral part of the city. Both were meticulously planned as landscape gardens; four centuries after the development of Bagh-e Babur, the nineteenth-century designers Frederick Law Olmsted and Calvert Vaux followed similar principles, devising various axial vistas within the park using lakes, pavilions, lawns, and the planting of indigenous and exotic trees and plants.

 The gardens in Kabul and New York were both created as sites that promote contemplation and relaxation, expressing the notion of an earthly paradise, and as spaces embedded in the aesthetic and civic context of their time. As such they are not only symbols, but also tools that mirror and shape social and political relations.[1] The only building to be confidently slotted into the eastern edge of Central Park was designed by Vaux with his partner Jacob Wrey Mould: it is The Metropolitan Museum of Art, which opened in 1880, just two decades

after the first part of Central Park opened in 1858–59. Surveying the park from the Metropolitan Museum roof, Qureshi enthused about its unique view of a beautiful landscape, identifying both the Museum and the park as a conjoined entity, whose histories are rooted in the civic and ideological symbolism of their origins—and which continue to this day as places to invigorate, entertain, and educate the public.

Indeed, a hallmark of Qureshi's project is this synthesizing of the passage of time in paint, not only as an immediate record of his process of making the work, but also in his deep connection to the tradition of miniature painting. From his student days at the renowned National College of Arts in Lahore (where he teaches as an assistant professor), he has taken a critical yet respectful approach to the miniature, updating its historical content and opening up the constraints of its form, while retaining its refined execution and, most importantly, its significance as a carrier of complex ideas, among which have always been oblique political references harking back to the Persian Empire.

Qureshi's two strands of artistic practice oscillate between the discipline and reinvention of the miniature format, and the expansive scale of architectural spaces. In accepting the invitation to create a work on the Metropolitan Museum roof, Qureshi carefully considered both the spatial logic and the historic legacy of its overlook. He has created a painterly meditation on humankind's vital relationship to nature over eons: from the elemental matrix of liquid color emerges nature as form, luxuriant blooms of leaf whose colorful exuberance belie the draftsmanship and precision of line with which they are limned. As if emerging toward the light from beneath the roof's concrete paving stones, the foliate motifs suggest not only the primordial life force beneath the surface of the natural world, but also its organic evocation as essential energy, the creative imperative that has motivated artists from prehistoric times to today, the evidence for which is contained within the museum below.

It is for the spirit, sensitivity, and complexity of Qureshi's vision, condensed into works of compelling simplicity, that we have chosen him to inaugurate a new series of Roof Garden commissions, for which this publication is also the first.

Note

1. *Babur's Garden Rehabilitation Framework* (Kabul, Afghanistan: Aga Khan Trust for Culture, 2004), http://www.akdn.org/publications/2004_afghanistan_babur.pdf.

Keeping Control of the Line

A Conversation with Imran Qureshi

Ian Alteveer and
Navina Najat Haidar

The work of Imran Qureshi is marked by rich dualities. In his recent large-scale, site-specific paintings, leaks and spills of red paint splattered on walls and pavement seem at first to record the trace of some unspeakable violence. On closer inspection, however, verdant thickets of ornamental leaves sprout from these lurid stains. The source of these patterns are the detailed works on paper Qureshi layers with painstaking brushwork and gilt in the style of the sixteenth- and seventeenth-century Mughal miniature painters. He studied this tradition at Lahore's National College of Arts (NCA), where students who specialize in miniature painting learn its rigorous techniques. This training includes everything from gilding and handcrafting the paper for the paintings' supports to the meticulous application of color with tiny, squirrel-fur brushes of their own making. As an assistant professor in miniatures at NCA, Qureshi now teaches this practice to a new generation of students.

Within the strictures of this centuries-old discipline, Qureshi continues to find remarkable room to play. In his works of the early 2000s, the artist layered the pages of old textbooks found at a weekend street market with drawings of scissors, plantlike forms, and ballistic missiles (see fig. 3). For other paintings he reproduced the precisely diagrammed grids of crosshatches and stippling from classroom exercises, then subverted their geometries with efflorescences of ornamental pattern. In more recent examples—as in his Moderate Enlightenment series (2006–, fig. 5; pp. 4 and 6)—detailed portraits of friends and family in contemporary dress are set in sumptuously gilded landscapes, packed with the meticulous detail one finds in folios commissioned by the Mughal emperors (1526–1857). For Qureshi, there is an exquisite tension between the stringent parameters of this antediluvian practice and the modernity of his sitters—one that speaks in part to the frictions of a world in which novelty collides daily with orthodoxy.

Qureshi visited New York this past winter to survey his proposed rooftop site at the Met. To illuminate this pull between the past and present, we sat down with the artist to discuss the grand tradition he studied and the myriad ways he works to reinvent it.

Ian Alteveer
Associate Curator,
Modern and
Contemporary Art

Imran, I first want to ask how you became an artist.

Imran Qureshi From childhood, I was into artistic activities and creative things. I didn't know that it could be a profession, though—that one can become an artist and one can study art. We were living in Hyderabad, which is not a small town, but it is not a big city either. When I was in grade eight or nine, my uncle said, "You should go to the National College of Arts, which is in Lahore. It's a wonderful place, and it would be very nice for you." I told this to my father, and he took me to Lahore and showed me the school. He said, "Now you decide whether you want to be an artist—do you want to take it as a profession?" At that time everybody was going into either medicine or engineering. But my family was quite open. My sister Seema, encouraged by my father, entered architecture school, and for a time, I rendered drawings for her. My father was really good in that sense. He was supportive to the extent that he took me all the way from Hyderabad to Lahore, just to show me the art school.

Ian Alteveer And this was when you were a teenager?

Imran Qureshi Yes, that was when, in one year's time, I needed to make a decision about where to go to university.

Ian Alteveer Can you tell us more about your family? It sounds as though it wasn't just your father who was interested in the arts.

Imran Qureshi My grandfather, my mother's father, was a poet. Nobody was a visual artist in my family, but there was this appreciation for art, television, film, and literature. Everybody was into reading Urdu literature, and we would discuss it as well, which is not necessarily a common thing over there. I only realized later that we were brought up in such an environment. At the time, it was a very natural thing that my family members and cousins would discuss some book or some writer. And now there are quite a few artists in my family: my younger brother Faisal came to NCA to study graphic design and met his wife, designer Mahrosh Haidar, there. Of course, my wife, Aisha Khalid, is also a well-known artist.

Navina Haidar
Curator, Islamic Art
How did you find your experience at the National College of Arts in Lahore? It's considered quite a marvelous place by reputation.

Imran Qureshi It is. When I went there, I was slightly nervous. There were lots of people who came from Karachi and Lahore—the bigger cities—and their exposure to art was much greater than mine. The rules and requirements were really strict too, and I was worried I might not be able to complete my four years. In the first year, if you weren't clear about your subjects within a certain time, then the college expelled you. In the second year, you had just two chances before they would expel you. But I continued getting really good results mainly because I took it as a challenge to survive within that competitive atmosphere.

Navina Haidar You found the quality of the students very high?

Imran Qureshi Certainly. In my first-year class, for example, there were Bani Abidi, Risham Syed, Faiza Butt, Masooma Syed, Farida Batool—all extremely talented artists and really good names in Pakistani art right now. And Rashid Rana and Shahzia Sikander were two years ahead of me.

Navina Haidar What kind of interaction did you have with them?

Imran Qureshi In a way, my setup was different from theirs as I was in the Miniature Department. It was a very disciplined environment, and the teacher was very traditional. He expected us to sit quietly all day, work, and not do other things. I was always interested in the Painting Department, though, and would go there and talk to the students in that course. I ended up absorbing so much from them. Although I was trained very academically and I was following a certain discipline in a very strict way, my discussions with the painters have a lot to do with the way my work got to be the way it is today. That's where the uniqueness of my miniatures finds itself: they have the discipline of carefully painted imagery but, at the same time, deal with abstract mark making.

Navina Haidar I have always been curious about the National College of Arts, as it's known as a place that teaches you to produce miniature painting in

the traditional way. But does that mean traditional materials, styles, and techniques? What exactly are the traditions they teach?

Imran Qureshi It is not necessarily the whole school that teaches tradition, but the Miniature Department's way of teaching is quite formal. In the first year, we were made to copy a certain number of works from the canon of historical miniatures, which are from the Persian, Mughal, Kangra, Gujarati, and Rajasthani schools, and so on (fig. 1). And then they would slowly let us do our own thing and incorporate some of our own ideas.

Navina Haidar In terms of materials, were you taught to use traditional or modern ones?

Imran Qureshi We used traditional techniques at first: for instance, we learned how to laminate layers of paper to make the support called *wasli* and how to make our own brushes. We learned how to burnish the paper's surface and were taught how to do gilding on a miniature painting. At the same time, though, we were learning about substitutes for old materials. They didn't require us to go so far as to make our own colors from actual stone pigments or minerals.

Navina Haidar So it was a combination of older and newer materials?

Imran Qureshi Yes, and I realized so many things later on after I graduated. For the first exercise in the Miniature Department, they asked us to make a grid with squares of one by one inch using a pencil with a really, really long lead, carved to a sharp point. Then our teachers asked us to fill it up by making diagonal, parallel, horizontal, and vertical lines—to fill the boxes with really fine marks while keeping control of the line. This is the first exercise toward the traditional miniature painting, which I realized is so modern.

Ian Alteveer Yes, very. It sounds like a Sol LeWitt drawing. Of course pencil is not exactly a traditional material for miniatures, is it?

Imran Qureshi At least it's not traditional to make a grid and fill it with lines. To begin a traditional subject

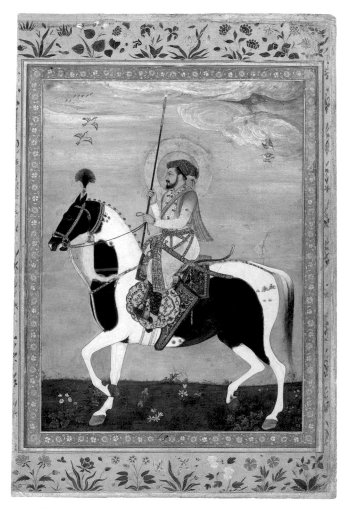

Fig. 1. "Shah Jahan on Horseback," Folio from the *Emperors' Album*, painting by **Payag** (active ca. 1591–1658), India, ca. 1630. Ink, opaque watercolor, and gold on paper, 15 5/16 × 10 1/8 in. (38.9 × 25.7 cm). The Metropolitan Museum of Art, New York, Purchase, Rogers Fund and The Kevorkian Foundation Gift, 1955 (55.121.10.21)

with an extremely modern, graphic image was very interesting. Later on, in 2006, I did a series of work (see *Leakage*, fig. 2), where I used this grid of lines in dialogue with my own imagery—the foliate patterns derived from plants—in contrast with that very rigid, mechanical kind of pencil marking.

Ian Alteveer That reminds me in a way of the works you made from the pages of a tailoring handbook (see *How to Cut the Front of a Burqa*, 2002, fig. 3). You've described going to a book market in Lahore every Sunday to look for old books, either literary works or technical manuals. I wonder if part of the appeal was the way that those books were instructional, that they told the tailor how to cut a garment in specific ways. In a sense, you create a tension in those drawings between the didactic aspects of the texts and your more free-form illustrations.

Imran Qureshi Yes, I think this is the same thing that I've mentioned before: I always like to make a dialogue between a very disciplined kind of mark making and the very open or free kind of abstract or organic imagery I use.

Fig. 2. **Imran Qureshi.** *Leakage,* 2006. Gouache on paper, 8 ⅞ × 10 in. (22.5 × 25.5 cm). Courtesy the artist and Corvi-Mora, London

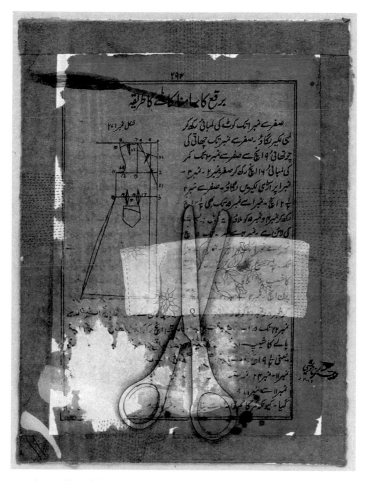

Fig. 3. **Imran Qureshi.** *How to Cut the Front of a Burqa*, 2002. Gouache on paper, 11 × 7 ⅞ in. (28 × 20 cm). Courtesy the artist and Corvi-Mora, London

Navina Haidar I'm still fascinated by the success of the college of arts. Amid world politics and global conflicts, you have this amazing college producing students with such great work. However, if you deal with the traditional arts, as I do, and look at Lahore in the Mughal period, historically it's always been a city of great artistic production.

Ian Alteveer To Navina's point, do you find the quality as good as at other contemporary institutions?

Imran Qureshi The NCA is obviously playing a major role, but lots of interesting stuff is happening all over Pakistan, even in really small towns. When I travel as a juror or examiner, I am always impressed to see brilliant ideas coming from remote places. Unfortunately, the artists are not often available to the mainstream art public, so they don't get good exposure or responses.

Navina Haidar How do you judge a work of art, whether yours or another artist's? Do you find the aesthetic component significant for you personally? Where do you position yourself?

Imran Qureshi For me, concept is the beginning point of something, and after that is developed, there's another kind of dialogue that starts with the world and the art, between the artist and the work itself. When I'm making a work, I don't think only about the concept, but the concept cannot be allowed to run away. One shouldn't be too conscious of all that, as it might stop progress in your practice.

Even when I'm making a miniature painting, I start from one point and then develop outward. I don't draw the whole thing at once—even the landscape. I mostly prefer to do everything directly with the paint, instead of sketching it out and then filling in the colors. I might have something in mind, but then I start enjoying the process. For example, I will start the base of a landscape (fig. 4), then start rendering, then developing the grass on it, the plants, and so on. But I do it directly with the paint, for the most part.

Navina Haidar That's very interesting because especially in Lahore about four hundred years ago in the workshops of the Mughal emperor, you had one artist executing the composition, another one executing the faces, and a third

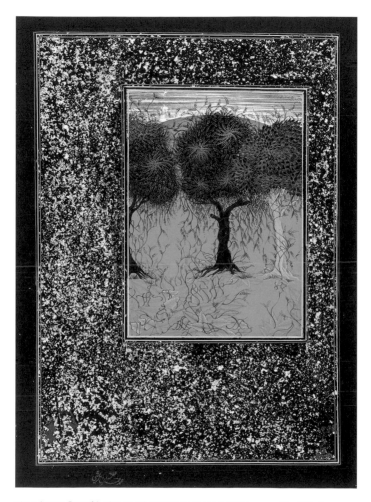

Fig. 4. **Imran Qureshi.** *Threatened,* 2010. Gouache and gold on paper, 13 × 9 ⁷⁄₁₆ in. (33 × 24 cm). Collection of Amna and Ali Naqvi

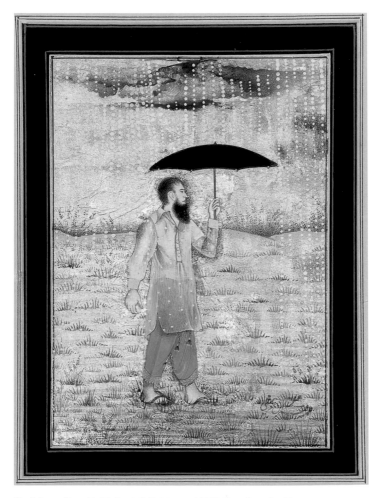

Fig. 5. **Imran Qureshi.** *Moderate Enlightenment*, 2009. Gouache and gold on paper, 20 × 9 ½ in. (51 × 24 cm). Collection of Amna and Ali Naqvi

doing the color. They were all assigned different jobs, but certainly the whole outline of the composition was laid out by, let's call him, a master composer. The inscriptions tell you who did what. While it's not always the case, in the Akbar period (reigned 1556–1605), for example, they did that quite a bit. So it's interesting that you start from a single point and develop it outward, rather than starting with a sketch of the full composition.

Imran Qureshi Yes. Of course, I make two types of works, one abstract or semiabstract, the other figurative. For the formally painted or figurative works, I usually draw the main figure and then everything else comes later. I'll just draw the basic structure, but I don't do all the detail. Of course I was trained that we were supposed to do the whole drawing first—

Ian Alteveer In the traditional sense that Navina just described?

Imran Qureshi Yes, very systematically. But when I started my own practice after college, I found that if I did everything on the first day, there would be nothing left to excite me later. It would become about the labor, rather than getting something different every day from my work.

Navina Haidar That makes sense. It's of course the composition—that was always what the great master would do because that was conceptually the most exciting—that would lay out the work's possibilities.

Ian Alteveer You were saying that you have a figurative practice—the one that uses traditional techniques, *wasli* paper, gouache, and gilt (fig. 5). Would your more abstract work be your site-specific installations or the other works on paper that use drips, spills, and your foliate motif (fig. 6)? How do you create those works?

Imran Qureshi Yes, the foliate motif. Those are done very spontaneously. I just start from one mark or one spill and then develop the story around it.

Ian Alteveer Would you say they involve chance or accident?

Imran Qureshi Yes, I think I always enjoy accident and chance because every time it gives you something new. It also goes specifically against this tradition of miniature painting. Indeed, if some accident happened with somebody's miniature painting at school, they would get really upset—as if some small drip had completely destroyed the work. I was so much calmer when something like that happened because I was always intrigued by accident, wanting to examine the results and investigate them further. I always found something new out of it. I enjoy accidents.

Navina Haidar But some of your work has also been about deconstructing this—no? That you've actually taken what would have been a normal completed work and undone it in some sense. I'm thinking of the work that recently entered the Museum's collection (*U Turns*, 2004, fig. 7). Does that translate to your installations? You're creating forms with very fine brushwork that requires intensive labor and handwork, skills that you would have applied on a tiny scale to a huge surface.

Imran Qureshi My temperament is actually very different from that of a miniature artist. I enjoy talking to people, and I like performances—for a while, I was into theater. If miniature painting is something for which I must carefully sit and concentrate, after a few hours I just want to go completely against that attitude.

The site-specific approach reflects that public side of my personality. Scale never bothered me. Whether small or big, each has its own beauty. And in my art practice, I always like to strike a balance. If I'm doing lots of abstract work or site-specific work, before long I go back to the traditional miniature. You might not have noticed, but there are certain times when I make very carefully painted portraits or figurative works of landscapes exactly because I want to see whether I still have it in me! My teacher always used to say that my abstract work might destroy the ability to make a miniature painting.

Ian Alteveer The danger of large-scale painting.

Imran Qureshi Yes, large-scale painting or mixed media or even miniatures with other kinds of playfulness in them. I think my skill has improved a lot since graduation. I was not that good in the beginning at painting traditionally, in terms of skills at rendering, control of a line, or sense of color. My

Fig. 6. **Imran Qureshi.** *Opening Word of This New Scripture*, 2011. Gouache and gold on paper, 30 × 44 in. (76 × 112 cm). Courtesy the artist and Corvi-Mora, London

Fig. 7. **Imran Qureshi.** *U Turns*, 2004. Ink, gouache, watercolor, graphite, and metallic paint, and Letraset transfer on torn and pasted papers, 10 ¾ × 14 ¼ in. (27.3 × 36.2 cm). The Metropolitan Museum of Art, New York, Purchase, The George Economou Collection Gift, 2013

experiments in abstraction provide something really positive to my art practice.

Navina Haidar Can I ask you about your freedom to make the artistic decisions that you do? Obviously it's not Lahore four hundred years ago, where, had you been a miniature painter, you would have been working for the Mughal emperor. If he would have said, "We're going to do an illustrated manuscript of the *Divan of Anwari*, the *Akbarnama*, or some fantastic text, or history or philosophy; we will illustrate it with one hundred miniatures; and they will all be painted in this way," in this environment, you would have been part of a workshop—a *karkhana*.[1] You would have had to paint in an imperial style that reflected not just your skill as an artist, but also the glory of the Mughal vision as a whole. But now Lahore is still filled with artistic spirit and the patron is no longer the Mughal emperor. Perhaps it's a scarier place because you're out there on your own, without a protective structure or patronage structure?

Imran Qureshi Which is a good thing!

Navina Haidar Yes! [They laugh.] But, from your vantage point, as free as you are from any of these trappings, when you look back at the Mughal period, do you sense the individual artists behind the traditional miniature paintings as one often can in contemporary art? Or do you feel that it was a fundamentally different place for the artist then?

Imran Qureshi Well, I can tell you a story. When I was a student, I decided that I wanted to take painting, not miniatures, as my area of specialization. The National College of Arts has the requirement that in your third year, you have to decide your specialization—painting, printmaking, sculpture, or miniature painting. At the beginning of my course work, I took painting as my area, because I thought maybe miniature is not my style. I saw more freedom in painting and that it was more about me as an individual artist.

Then a teacher named Bashir Ahmed (fig. 8), a very distinguished figure in the Miniature Department, said over and over, "You should do miniature painting." Finally I stopped passing through his studio and the Miniature Department entirely on my way to Painting because he was always saying the same thing, "You just have to do miniature." I would reply, "Sir, I just cannot do it because it's not my style!" He said—sorry I have to say it in Urdu—

Fig. 8. Bashir Ahmed teaching in his studio at the National College of Arts, Lahore, Pakistan, ca. 1990s

"Mein to daig se aati hui khushboo se bata sakta hun ke andar chawal kis 'quality' ka hai," which translates roughly to "by the fragrance coming out of the pot, I can tell the quality of the rice inside."

I thought, if the teacher says so, I should respect his opinion and seriously think about it. Then I had the clear idea that miniature painting was something that I could only learn at the National College of Arts; I could do painting anywhere in the world. On the other hand, if I'm going to choose miniature as my area of specialization, then I must challenge its boundaries. I should try to do something new within it, to make it a strong mode of expression—an endeavor that was not necessarily common at that time.

So I took miniature as my area. All the while I was thinking about what contemporary miniature painting is all about, trying to find substitutes for its traditional materials, and trying to find out how one can get the same kind of essence of miniature painting through modern means. I was exploring it at different levels, and I think that developed my art practice as an independent artist. At times, my teacher would say such things as, "There's no miniature painting without a figure in it," and then I would challenge these sorts of statements in my practice. There was a debate between us—a very healthy one, in fact, that provoked a lot of other things for me. My logic was that, indeed, we are not court painters. That was a different time, a different situation, a different environment. We are not restricted to the same limits. And then I started thinking about the different schools of miniature painting. When we see a painting, we can now say, "This is Kangra," for example.

Navina Haidar Yes, this idea of *qalam*.

Imran Qureshi This *qalam*—their style—through the painters' palette, color, or stylization. This style is

Kangra; this is Mughal; this is Gujarati; this is Persian. At this point in my education, I realized that some of the other miniature artists around me at NCA had their own styles. They seemed to develop so naturally. One can immediately say this is Nusra Latif Qureshi, this is Aisha Khalid, this is Talha Rathore, and so on. And there was something new in this whole tradition of miniature painting: one can recognize a painting through the individuals, not through the painting school.

Navina Haidar It's interesting how artists for so many years were able to subsume themselves to a school. In working with historical material, on the basis of the tiniest clue of this painting or that painting, one makes an attribution, which is very tentative; then four scholars will come and denounce you completely for it. But the point is, it's so hard to do when the canon is very precise, the school is very well defined, and everyone had to work within the style of the Mughal period of 1625 or Kangra of 1750. When you look for individual expressions in that kind of restriction, it comes up in a very unusual way. As someone working in the contemporary world, you have such an open landscape around you now.

Imran Qureshi I think in part that openness is made possible, paradoxically, because of the strict attitude my teacher had. It came as a reaction. People tried to find—because they were artists at the end of the day—their own ways of expressing their feelings or emotions.

I credit my teacher for that discipline. I don't see it as something negative. The discipline returns to us in a very natural way, so that now, no matter what I am thinking in making a work, one can see a connection with the miniature-painting tradition. We feel comfortable seeing things through that tradition.

Navina Haidar That's a very important part, this feeling of inheriting the past in a healthy way—not as a kind of oppression, but as a lineage to which you relate and from which you derive strength and depth in your work. That's an incredibly vital part of your work and that of so many other young artists today from South Asia—or in many other parts of the world for that matter.

Can we ask you about your installation for the Sharjah Biennial in the UAE in 2011 (*Blessings upon the Land of My Love*, fig. 9; pp. 54–55)? It is one of the reasons why you have been celebrated recently. In photographs of the site, taken from far away,

one has a sense of the enveloping color of your painting, but it is in close-ups (fig. 10) that you realize that individual areas have been painted with an extraordinary amount of detail.

Ian Alteveer It has the look of liquid that has been spilled and splattered and then worked into shapes: foliate, leafy patterns that cover the courtyard.

Imran Qureshi The curator that year, Suzanne Cotter, who had organized my solo show at Modern Art Oxford in 2007 (fig. 11), showed me the whole site of the biennial and gave me the freedom to choose any place to install.[2] There were many different spaces and buildings to choose from in Sharjah. At the end of the day, we went to this wonderful building called Bait al-Serkal, which had a very large courtyard with a very obvious sewer drain in its center.

It reminded me immediately of courtyards with gardens in private houses, and I was taken with the idea of filling it with flowers in this kind of bloody red. I wanted an element of attraction and repulsion at the same time, which seemed to work so well in that space. Something that invites you in and then repels you. Or repels you at first, then invites you in later—working in both ways.

There was also so much violence around us at that time—even now—and there was this Middle Eastern political movement—

Ian Alteveer The Arab Spring?

Imran Qureshi The Arab Spring, yes. And there was so much violence in Pakistan too.[3] It disturbed me a lot.

Ian Alteveer Is it because, all of a sudden, it was happening in your city where it had not appeared so much before?

Imran Qureshi Yes, Lahore seemed suddenly to become their main target.

Ian Alteveer Why do you think that was?

Imran Qureshi Maybe this was their strategy, to target one thing, to pressure the street or people.

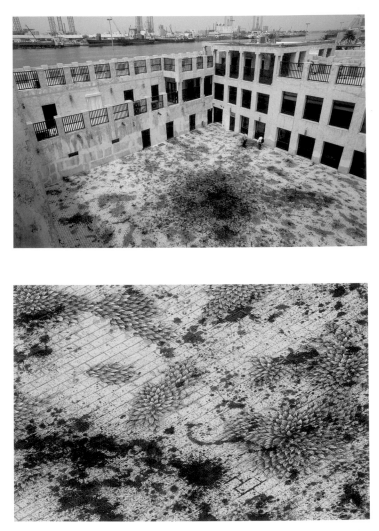

Figs. 9 and 10. **Imran Qureshi.** *Blessings upon the Land of My Love*, 2011. Acrylic. Installation views, Bait al-Serkal courtyard, Sharjah Biennial, United Arab Emirates, 2011

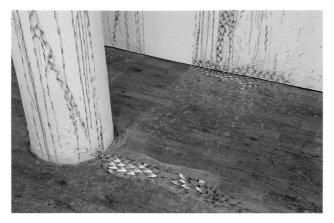

Fig. 11. **Imran Qureshi.** Detail of an untitled installation, 2007. Acrylic.
Installation view, "Encounters: Imran Qureshi," Modern Art Oxford, 2007

Navina Haidar When I saw images of the Sharjah installa-
tion, I was just stunned and very powerfully
moved. I thought not just about South Asia, but about all of the world,
where a culture of violence seems to be everywhere, to the point
where it's deep in our psyche. That work struck a chord with me.

Imran Qureshi I was very excited about this work while I was
making it for exactly those reasons. But it was
quite challenging. For one, it was difficult to see the whole expanse
of the courtyard at once—it was so big. I spent a lot of time racing
to the parapet at the top to look down and try to read it as a whole.
Then returning below, I would have to figure it out and remember
what part I had identified from above. I developed it step by step. But
as happy as I was with this work, I still did not expect such a strong
response from people. It was amazing. People were crying—and, at
first, I thought maybe I had done something wrong! [Laughs]
Everybody seems to have their own connec-
tion to or feel an affinity with that work. Some people relate it to
global violence—although there were many different interpretations,
some rooted in the building's own past (fig. 12).[4]

Navina Haidar Also the color was very dramatic, just looking
at the application of the red itself and think-
ing of all the miniatures that I've seen depicting bloody battles from
the 1600s and 1700s and so on. When you actually look at the blood

and the way they painted it, it's a very particular pigment, not tomato red or bright red; it's a kind of layering of purply red, and a quite watery one in some ways. The thickness of its color only comes up as you have successive layers built up. Even though your work couldn't have been more removed from an Indian miniature of historic times, I immediately saw Mughal-period blood in there.

Ian Alteveer Is the specific color that you use for these large-scale installations one you work with regularly?

Imran Qureshi It's called perylene maroon. I used red before in my works on paper, but Sharjah was where I used it on such a large scale for the first time. I was already using this red in my work, which reads more like pink sometimes as well as blue, and which together, on white surfaces, reads as the colors of the American flag (fig. 14). The rich color of this red played a very strong role in developing my imagery. Whenever I was mixing it or washing my brush, if it was on my hand and I was cleaning it off, or when it was draining out of the sink, it looked so real—like blood.

Ian Alteveer So it was the color that pushed your work further?

Navina Haidar And the foliate forms that you use are very Pahari school (fig. 17). Were they meant to evoke that?

Imran Qureshi Yes. They came from Pahari paintings (fig. 15) and started at the time when I was making figurative works and using lots of foliate forms. For me they were very formalized representations of landscape with those particular species of trees.

Ian Alteveer Are these the drawings of trees you've described as looking like lollipops?

Imran Qureshi Lollipops, yes (fig. 16). Then slowly the forms became more and more abstract for me.

Ian Alteveer So the leaves of the round-shaped trees eventually became the blue roundels you've installed in various places (fig. 18)?

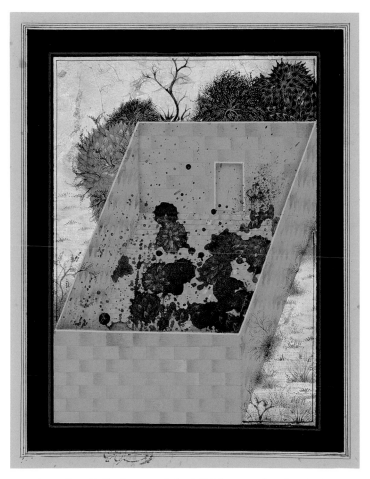

Fig. 12. **Imran Qureshi.** *Blessings upon the Land of My Love*, 2011. Gouache and gold on paper, 8 ⅝ × 6 ⅝ in. (22 × 17 cm). Courtesy the artist and Corvi-Mora, London

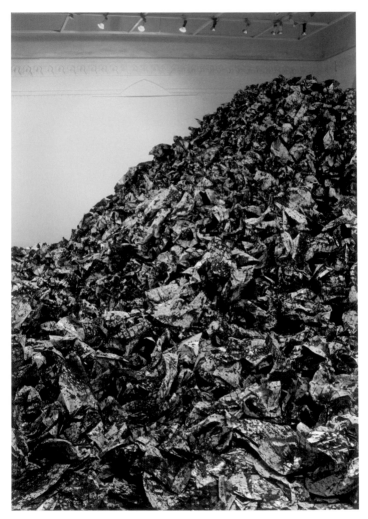

Fig. 13. **Imran Qureshi.** *And They Still Seek the Traces of Blood*, 2013. Offset lithographs. Installation view, ". . . And They Still Seek the Traces of Blood," Zahoor ul Akhlaq Gallery, National College of Arts, Lahore, Pakistan

Fig. 14. **Imran Qureshi.** Detail of *Perfect Harmony*, 2003. Gouache and pasted papers, 12 × 20 5/8 in. (30.5 × 52.5 cm). Courtesy the artist and Corvi-Mora, London

Imran Qureshi Roundels and oval shapes. I was using the leaf motif to fill up or decorate different things in my paintings—like the envelopes, missiles, and nuclear warheads. I was making a dialogue between these things that represented the idea of life—the leaves, for example—and death. I think my work is always in part about this idea of life and death (fig. 13).

Navina Haidar There is another installation work of yours that I've seen images of—the one in blue with the beautiful windows.

Ian Alteveer That was Imran's installation in Kabul, Afghanistan, at the Queen's Palace (*Time Changes*, 2008, fig. 19; pp. 52–53).

Navina Haidar It's amazing how the color conveys a completely different emotion and takes you in a completely different direction as a viewer. You have such a powerful control of color.

Imran Qureshi That work was for the exhibition curated by Jemima Montagu in Kabul in 2008.[5] She

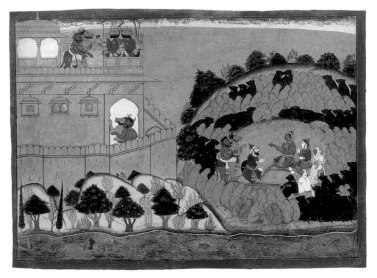

Fig. 15. "Rama Releases the Demon Spies Shuka and Sarana," Folio from a *Ramayana* series, attributed to **Manaku** (active ca. 1725–60), India, ca. 1725. Opaque watercolor, ink, and gold on paper, 23 ½ × 32 ¾ in. (59.7 × 83.2 cm). The Metropolitan Museum of Art, New York, Rogers Fund, 1919 (19.24.1)

Fig. 16. "Ragini, Possibly Asavari," Folio from a *Ragamala* series, India, ca. 1700–1710. Ink and opaque watercolor on paper, 7 × 6 ¾ in. (17.8 × 17.1 cm). The Metropolitan Museum of Art, New York, Rogers Fund, 1918 (18.85.1)

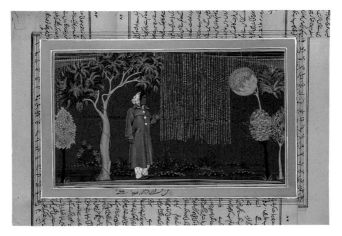

Fig. 17. **Imran Qureshi.** *Hajra Loves Rain*, 1999. Gouache on paper, 5 × 7 in.
(12.7 cm × 17.8 cm). Courtesy the artist and Corvi-Mora, London

was director of Turquoise Mountain, an NGO in Afghanistan. The
Aga Khan Trust for Culture had renovated the Queen's Palace and
Bagh-e Babur (Garden of Babur) in Kabul. Jemima thought to install
there a contemporary art exhibition about artists from Pakistan,
Afghanistan, and Iran—the first well-curated exhibition of contem-
porary art, I think, after years of war.

 When I went to see the site, they had given
me some room in the palace and I was not entirely happy. But when
I saw the hall I ended up using, with windows on one side and strong
sunlight casting the shadow of the windows on the floor, it was so
obvious and graphic. They had not planned to exhibit anything there,
but it was hard for me to avoid that space. I thought, "No, I want
to use this space!" and started going there again and again, when I
noticed that the shadows were different every time.

 For me, it became something about illusions. I
was thinking about how in recent history, but also for such a long time,
everything has been so uncertain in that country. By 2008 it was well
after September 11 and America's entry into Afghanistan—so perhaps
there was this idea that everything is okay. But it's not okay. You still
saw a lot of army presence, security barriers, and so on.

 I decided to think conceptually along that line.
I tried to create this illusion that when you see the image paired with the
light of the sun—when the shadow of the window matched my painted
imagery on the floor, you might think that was created by stained glass.
But of course there is nothing but paint—reality is different.

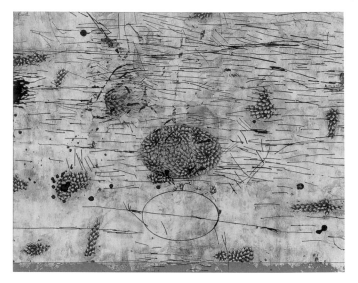

Fig. 18. **Imran Qureshi.** *Together in a Landscape*, 2007. Gouache and gold on paper,
9 ½ × 12 in. (24.1 × 30.5 cm). Courtesy the artist and Corvi-Mora, London

Navina Haidar So you intended that illusion?

Imran Qureshi Yes. To mark the spaces where I would paint
my blue foliate patterns, I masked the shadows at different times for each window. At the first one, I used masking tape to record where the sun came through the windowpanes at, let's say, noon. The squares of light were very small. After thirty minutes, I taped out the second window where the shadow was then slightly bigger, and then so on. So the work was of a kind that kept changing all day. Only at a certain time would a shadow perfectly fit one of the images and then move to perfectly fit, after some time, another painted image. And then, after some more time, it moved from there to fit onto another.

Ian Alteveer So it's sort of living.

Imran Qureshi It's more like a video, but without any technology or elaborate science.

Navina Haidar It's wonderful how it incorporates the passage of time in paint.

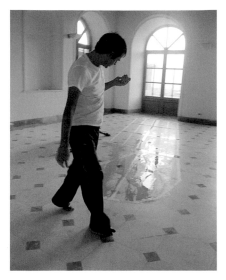

Fig. 19. Imran Qureshi installing *Time Changes* (2008), Queen's Palace, Bagh-e Babur (Garden of Babur), Kabul, Afghanistan, 2008

Imran Qureshi Yes, it's very much a kind of moving image.

Ian Alteveer Some of your art has a political edge to it, whether it's something people are attaching through their own experience or interpretation, or whether you deliberately open up the space to allow that to happen. Is that something that comes to you naturally or something you feel a responsibility to do?

Imran Qureshi I think it's very natural to me. Since childhood, the first thing I do at home is read the newspaper. Before getting dressed for school and having my breakfast, I used to go straight from my bed to the door, get the newspaper, and read it quickly.

Ian Alteveer So you've felt very engaged with current events and politics throughout your life?

Imran Qureshi Yes. Current events affected me a lot as a child. I have memories, for example, of being aware of something going on in Afghanistan

41

because Russia was there. It was at the time of the Geneva conference, and I remember reading those things.[6] I was probably not politically correct in my understanding of the news and events, but I was interested in reading about them.

Navina Haidar I grew up in India, and many of the social issues of the day affected everyone's heart, mind, and spirit—from the deprivation of certain levels of society, poverty, inequality, human-rights issues, even the animals and their lives, and nature. Artists were so much a part of expressing these things that everybody was feeling or thinking but unable to articulate and define. If not for those artists, who else would have taken those ideas, put them out there, and expressed them with such precision and creative insight? That's the big difference between contemporary art and the historical material I work with, which so often had to present either an official line or an idealization of the world in some way for one's patron.

Ian Alteveer Do you ever find space in those historical paintings for subversion or for different politics?

Navina Haidar It's hard to find it. Sometimes there are interesting psychological twists that tell you something about an artist who's rather peculiar or individual in his taste. There's a man in the eighteenth century who is known as the sadist Gangaram because he painted these incredibly vivid and awful scenes of, for example, a man who discovers his wife being unfaithful to him and hacks her lover to pieces on the bed.

Imran Qureshi Yes, that's that scene of infidelity, *Murder in Town* (ca. 1740, Knellington Collection, Harvard University Art Museums).[7]

Navina Haidar Yes, exactly. But was he a sadist and terribly interested in these ghastly scenes? Or is he faithfully painting some text or source that we don't really know? It's not clear. Or take Mansur (active ca. 1589–1626), the great naturalist. He was also trained as an illuminator and could do straightforward and very competent illuminations. He could do portraits, all kinds of things. But he rose to fame because of the sensitivity that his patron, Jahangir (emperor, reigned 1605–27), recognized as we do today: Mansur's feeling for nature, flowers, and animals;

his careful, almost scientific observation of them in some cases, but also his idealization. Through that precise observation, he idealized them to a point where he elevated these subjects. They became great portraits, even if they were not of a king. They were great portraits of a rose or birds (figs. 20 and 21).

Imran Qureshi Yes, and that was the best part about his practice. It was not about the king or queen.

Navina Haidar You sense Mansur the man, with a taste, soul, and feeling, and somehow you read it in his work. I have dealt with hundreds of works, of which a few have these extraordinary qualities. Within these strict canons, schools, and styles, it's difficult to discern difference. But when you do, it's very exciting.

Another example is our great elephant picture (*Portrait of the Elephant 'Alam Guman*, ca. 1640, fig. 22). This is not just a random elephant; he's a very famous one, and there were many such portraits in the Mughal period. This elephant was named 'Alam Guman, and his price, one lakh of rupees, 100,000 rupees, is also mentioned in the inscription.

Imran Qureshi Wow.

Navina Haidar He was captured in 1614 when the Mughals had a huge battle with the Maharana of Mewar (Amar Singh II, reigned 1597–1620), who was holding out against Mughal domination in one of the Rajput states. When Jahangir succeeded in crushing them, one thing he did was capture this elephant and then ride it into town—he talks about it in his memoirs—and distribute money. The Mewar state had to submit; they had to give up their great treasures. Then this elephant was moved to the Mughal capital, and he was first portrayed in a picture that's in the National Museum in Delhi that shows him much younger, with his calves.

That is one of the sweetest father-and-son pictures you'll ever imagine. And then here he is in about 1640, quite an old, grand elephant. He's still worth a lot of money. And he's shown in full grandeur. How do you find him? With his jewelry? Take a look at his links.

Imran Qureshi Yeah. I saw it in books, but I never thought it was so big.

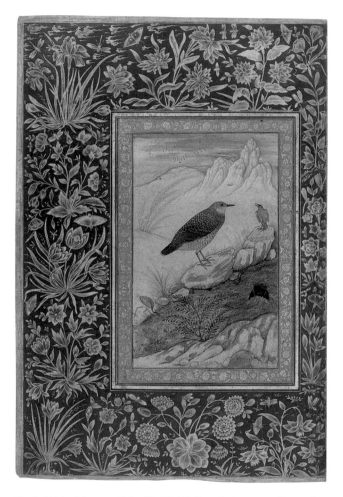

Fig. 20. "Diving Dipper and Other Birds," Folio from the *Emperors' Album*, painting by **Mansur** (active ca. 1589–1626), India, ca. 1610–15. Ink, opaque watercolor, and gold on paper, 15 ⅜ × 10 ¼ in. (39.1 × 26 cm). The Metropolitan Museum of Art, New York, Purchase, Rogers Fund and The Kevorkian Foundation Gift, 1955 (55.121.10.16)

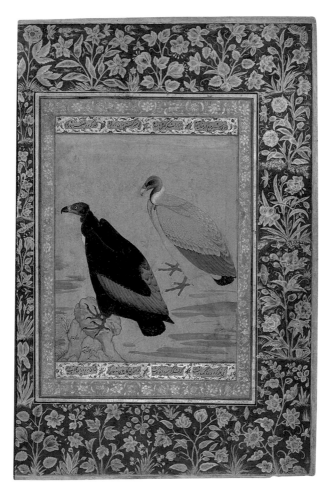

Fig. 21. "Red-Headed Vulture and Long-Billed Vulture," Folio from the *Emperors'*
Album, painting by **Mansur** (active ca. 1589–1626), India, ca. 1615–20. Ink,
opaque watercolor, and gold on paper, 15 ⅜ × 10 ¹⁄₁₆ in. (39.1 × 25.6 cm). The
Metropolitan Museum of Art, New York, Purchase, Rogers Fund and The
Kevorkian Foundation Gift, 1955 (55.121.10.12)

Navina Haidar Yes. It's a big, grand thing. If you look at those links with a magnifying glass, they're one of the best things in this painting, the elephant's chain (fig. 23). You see how contemporary it is? Bulgari or Chanel would love to design a chain like that. I'm not joking; it's really chic!

Ian Alteveer I also love the vivid reds and green.

Navina Haidar It's almost the same red as you painted in Sharjah, Imran—

Imran Qureshi Yes. And the elephant's body has such line; it has texture. Beautiful, fine lines on the skin.

Ian Alteveer The wonderful speckling all over the elephant's skin is so carefully painted in all these tiny dots.

Navina Haidar There must've been assistants, whose job was only to put in the texture, don't you think? Technically it's just a very demanding thing to produce.

Imran Qureshi Looking at the texture and the careful painting of that elephant's skin reminds me of when I was a student at the National College of Arts. Remember how I described my teacher as a traditionalist? He himself says that he's very traditional. But I was his student; my wife, Aisha, was his student; Nusra Latif was his student; Shahzia Sikander was his student—artists who have all brought something new and different to miniature practice. One time when I was painting, he suggested I use an airbrush to replace what we call *pardakht*, or stippling, because the airbrush also made dots. Later I realized that although he's very traditional and famous for that, he's doing such a modern thing at the same time.

Navina Haidar Yes, how interesting to replace that pointillism, that tiny stippling that we see in traditional painting, with an airbrush. That's the ultimate embrace of new materials and techniques despite his traditional ways. With all the forward thinking and modernity that we see in Imran's work and in the work of his generation, one of the sacred relationships is still that time-honored one between a teacher and student. It has very deep cultural roots in many parts of the world, but especially in the

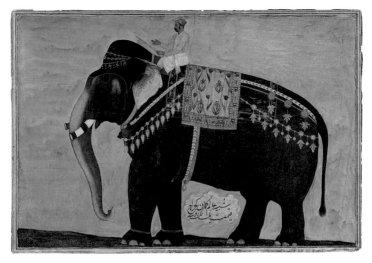

Figs. 22 and 23. *Portrait of the Elephant 'Alam Guman*, painting attributed to **Bichitr** (active ca. 1610–60), India, ca. 1640. Opaque watercolor and gold on paper, 12 ⅝ × 18 ⅛ in. (32 × 46 cm). The Metropolitan Museum of Art, New York, Harris Brisbane Dick Fund, 1996 (1996.98a)

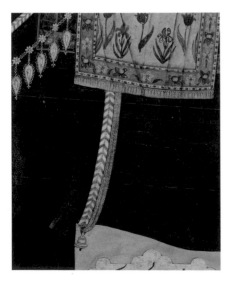

subcontinent. In some ways, it's valued even more than the relationship between a child and his parents because the latter is subsumed to the greater one that offers knowledge and learning—the whole thing is a higher level of exchange. I see from the way that you talk about your teacher that it's very important to you to mention and honor him—to acknowledge your lineage and descent from him. It's much more than just the institution.

Imran Qureshi People have this impression that we were two completely different personalities and that we always had arguments when I was a student and have lots of problems now that we work together in the same department. I respect what he taught through his very strict way because there was always some kind of reasoning behind everything. Whenever we asked him to tell us something, he would take so much time to answer. It was so irritating that we had to sit in his office and nothing would happen; we'd come back again and end up sitting in his room once more. Aisha, my wife, says that in this way, we got something out of such a big struggle and long wait, and that's why we value the things all the more. On the other hand, if I tell my students everything very quickly, they may not value those things in the same way, the way we both value those techniques and secrets of miniature painting. You see?

Navina Haidar What a nice note to end on—to return to the beginning.

Notes

1. The *Divan of Anwari* was a poetry anthology written by the twelfth-century poet Anwari and illustrated in Lahore for the emperor Akbar in 1588. The *Akbarnama*, a history of the emperor Akbar's reign (1556–1605), was composed in the 1590s.
2. The exhibition "Encounters: Imran Qureshi" was on view October 6–December 16, 2007.
3. Among other episodes of violence, on July 1, 2010, two suicide bombings occurred at Data Ganj Bakhsh, Lahore, considered to be the most important Sufi shrine in Pakistan. See Sabrina Tavernise and Waqar Gillani, "Suicide Bombers Strike Sufi Shrine in Pakistan," *New York Times* (July 2, 2010), p. A4.
4. Bait al-Serkal was originally built as a private home for a British government official in the nineteenth century, and by the 1960s it had become a city hospital.
5. The exhibition "Living Traditions: Contemporary Art from Afghanistan, Iran and Pakistan" was on view October 11–November 20, 2008, in Kabul, Afghanistan, and at the National Art Gallery, Islamabad, February 8–March 22, 2009.
6. The Geneva Accords of April 1988 brokered the withdrawal of Soviet troops from Afghanistan after a nine-year occupation that ended in 1989.
7. This gory scene is illustrated and described in detail by Stuart Cary Welch in *India: Art and Culture, 1300–1900* (New York: The Metropolitan Museum of Art, 1985), p. 375. For additional brief references to Gangaram, see Karl Khandalavala, Moti Chandra, and Pramod Chandra, *Miniature Painting: A Catalogue of the Exhibition of the Sri Motichand Khajanchi Collection* (New Delhi: Lalit Kalā Akademi, 1960); and Vijay Pinch, "Gosain Tawaif: Slaves, Sex, and Ascetics in Rasdhan, ca. 1800–1857," *Modern Asian Studies* 38, no. 3 (July 2004), pp. 559–97.

Selected
Installations

Singapore
Kabul
Sharjah
Sydney
Berlin
New York

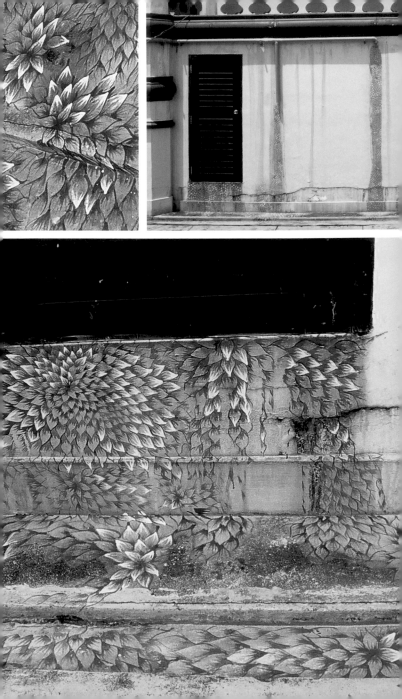

Wuzu 2, 2006

Acrylic

SULTAN MOSQUE, SINGAPORE BIENNALE

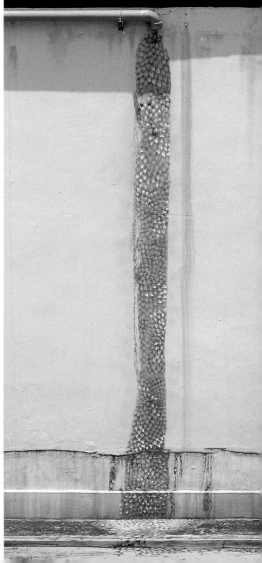

Time Changes, 2008

Acrylic

"LIVING TRADITIONS: CONTEMPORARY ART FROM
AFGHANISTAN, IRAN AND PAKISTAN," QUEEN'S
PALACE, BAGH-E BABUR, KABUL, AFGHANISTAN

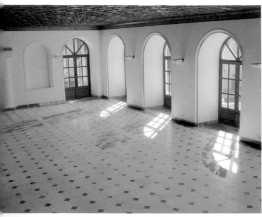

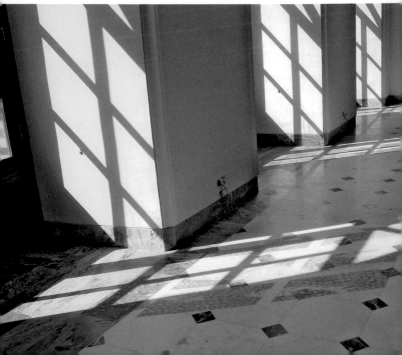

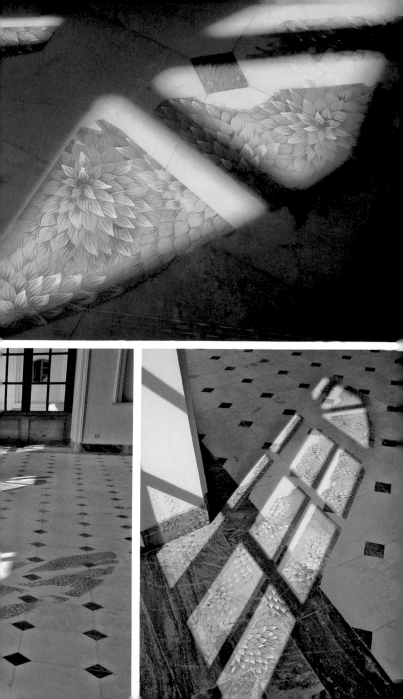

Blessings upon the Land of My Love, 2011

Acrylic

BAIT AL-SERKAL COURTYARD, "PLOT FOR
A BIENNIAL," SHARJAH BIENNIAL, UNITED
ARAB EMIRATES

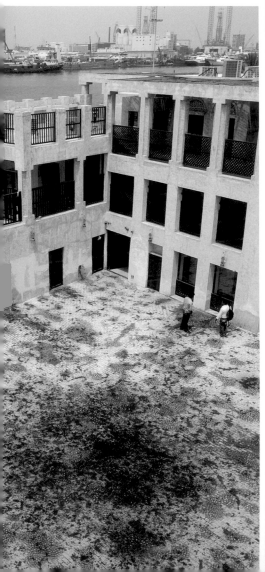

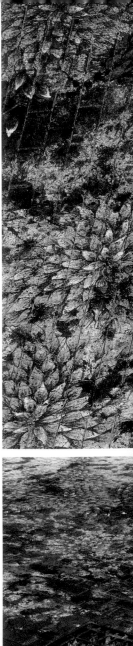

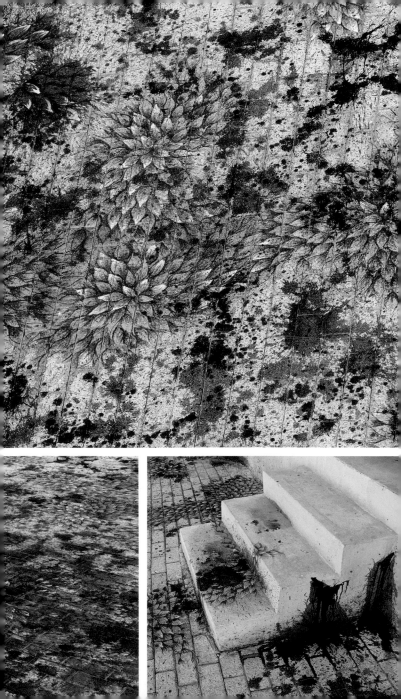

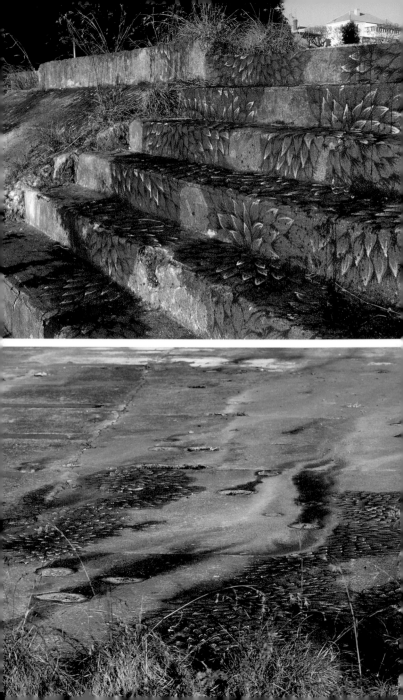

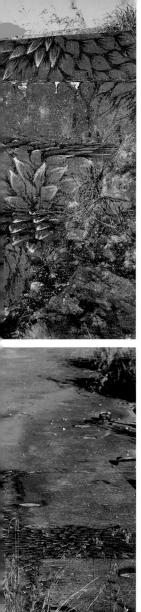

They Shimmer Still, 2012

Acrylic

COCKATOO ISLAND, "ALL OUR RELATIONS,"
BIENNALE OF SYDNEY

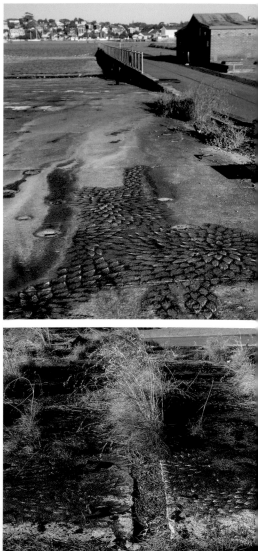

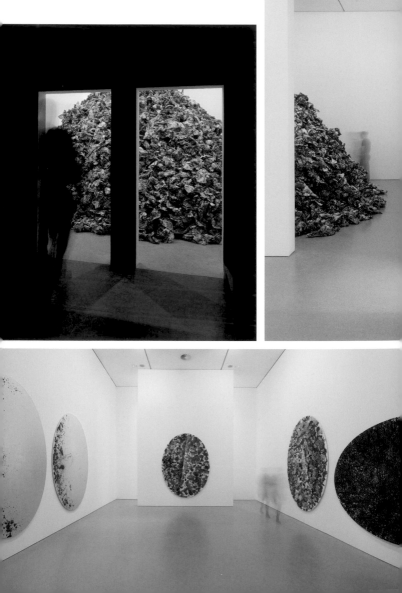

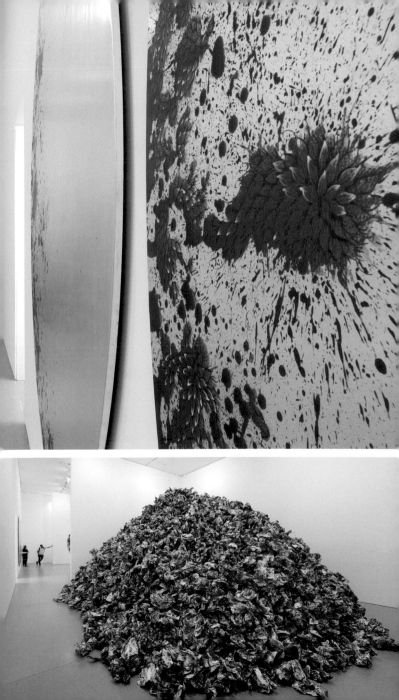

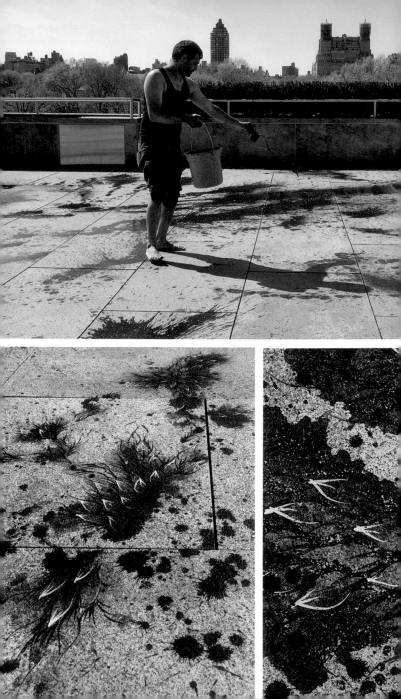

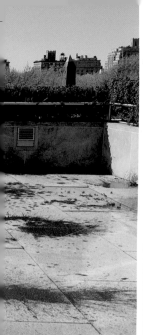

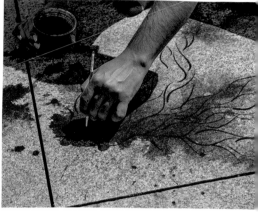

Imran Qureshi in The Iris and B. Gerald Cantor Roof Garden, 2013

"THE ROOF GARDEN COMMISSION: IMRAN QURESHI," THE METROPOLITAN MUSEUM OF ART, NEW YORK

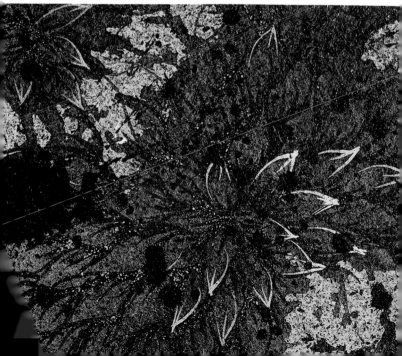

Selected Exhibition History

Born 1972 in Hyderabad, Pakistan

Lives and works in Lahore, Pakistan

B.A. in Fine Art, National College of Arts, Lahore, 1993

Solo Exhibitions

1996
Rohtas Gallery, Islamabad, Pakistan

2001
Admit One Gallery, New York

2002
Chawkandi Art, Karachi, Pakistan

2004
Corvi-Mora, London

2007
"Encounters: Imran Qureshi," Modern Art Oxford

2010
"All Are the Colour of My Heart," Rohtas 2, Lahore, and Chawkandi Art, Karachi

2013
". . . And They Still Seek the Traces of Blood," Zahoor ul Akhlaq Gallery, National College of Arts, Lahore, Pakistan

"Imran Qureshi: Artist of the Year 2013," Deutsche Bank KunstHalle, Berlin

Two-Person and Group Exhibitions

1999
Asia-Pacific Triennial of Contemporary Art, Queensland Art Gallery, Brisbane, Australia

2000
"Tristan: Another Vision; Fifty Years of Painting and Sculpture from Pakistan," Brunei Gallery, School of Oriental and African Studies, University of London; Huddersfield Art Gallery, United Kingdom; and Victoria Art Gallery, Bath, United Kingdom

2004
"Playing with a Loaded Gun: Contemporary Art in Pakistan," apexart, New York, and Kunsthalle Fridericianum, Kassel, Germany

"Contemporary Miniature Paintings from Pakistan," Fukuoka Asian Art Museum, Japan

"Expander," Royal Academy of Arts, London

2005
"Beyond Borders: Art from Pakistan," National Gallery of Modern Art, Mumbai

"Karkhana: A Contemporary Collaboration," Aldrich Contemporary Art Museum, Ridgefield, Connecticut

2006
"I Love My Country But I Think We Should Start Seeing Other People," Jack Hanley Gallery, San Francisco

"Beyond the Page: Contemporary Art from Pakistan," Asia House, London, and mac, Birmingham, United Kingdom

Singapore Biennale

2007
"Aisha Khalid, Imran Qureshi," Corvi-Mora, London

"Portraits and Vortexes," The Experimental Gallery, Hong Kong Arts Centre

2008
"Living Traditions: Contemporary Art from Afghanistan, Iran and Pakistan," Queen's Palace, Bagh-e Babur (Garden of Babur), Kabul, Afghanistan

2009
"Die Macht des Ornaments" [The Power of Ornament], Österreichische Galerie Belvedere, Vienna

"East–West Divan: Contemporary Art from Afghanistan, Iran and Pakistan," La Scuola Grande della Misericordia, Venice

"Outside In: Alternative Narratives in Contemporary Art," University Museum and Art Gallery, The University of Hong Kong

"Hanging Fire: Contemporary Art from Pakistan," Asia Society, New York

2010
"Aisha Khalid, Imran Qureshi," Corvi-Mora, London

"Beyond the Page: The Miniature as Attitude in Contemporary Art from Pakistan," Pacific Asia Museum, Pasadena

"Mazaar Bazaar," Zahoor ul Akhlaq Gallery, National College of Arts, Lahore

2011
"Plot for a Biennial," Sharjah Biennial, United Arab Emirates

"Realms of Intimacy: Miniaturist Practice from Pakistan," Contemporary Arts Center, Cincinnati

"Painting Show," Eastside Projects, Birmingham, United Kingdom

2012
"All Our Relations," Biennale of Sydney

2013
"Il Palazzo Enciclopedico" ("The Encyclopedic Palace"), Venice Biennale

Bibliography

Ali, Atteqa. "Postmodernism: Recent Developments in Art in Pakistan and Bangladesh." Heilbrunn Timeline of Art History. http://www.metmuseum.org/toah/hd/pmpk/hd_pmpk.htm.

Ata-Ullah, Naazish, et al. "The Semiotics of the Nation's Icons: The Art of Truck and Miniature Painting." In *Mazaar, Bazaar: Design and Visual Culture in Pakistan*, edited by Saima Zaidi, pp. 22–35. Karachi, Pakistan: Oxford University Press, 2009.

Cotter, Suzanne, Amna Tirmizi Naqvi, and Virginia Whiles. *Portraits & Vortexes*. Vol. [2], *Imran Qureshi*. Hong Kong: Gandhara-art, 2007.

Dawood, Anita, and Hammad Nasar, eds. *Beyond the Page: Contemporary Art from Pakistan*. London: Asia House, 2006.

Hashmi, Salima. *Hanging Fire: Contemporary Art from Pakistan*. New York: Asia Society Museum, 2009.

Husslein-Arco, Agnes, and Sabine B. Vogel, eds. *Die Macht des Ornaments*. Vienna: Belvedere, 2009.

Hütte, Friedhelm, ed. *Imran Qureshi: Artist of the Year 2013*. Frankfurt: Deutsche Bank, 2013.

Naqvi, Amna Tirmizi, and Jemima Montagu. *Imran Qureshi: Blessings upon the Land of My Love*. Hong Kong: Gandhara-art, 2010.

Nasar, Hammad, ed. *Karkhana: A Contemporary Collaboration*. Ridgefield, Conn.: Aldrich Contemporary Art Museum; London: Green Cardamom, 2005.

Qureshi, Imran. *Side by Side*. 2 vols. London: Raking Leaves, 2009.

Whiles, Virginia. *Art and Polemic in Pakistan: Cultural Politics and Tradition in Contemporary Miniature Painting*. London: Tauris Academic Studies, 2010.

Acknowledgments

Qureshi's deceptively simple paintings belie a complex process that the artist largely undertakes alone. This exhibition and its catalogue, however, required the work of a talented many. Deep thanks are due to Imran Qureshi's assistant, Shoaib Mahmood, who aided the artist during the installation, as well as Tommaso Corvi-Mora, Tabitha Mackness, and Clare Holden of Corvi-Mora, London. Christofer Habig, Friedhelm Hütte, Julia Magnus, Britta Färber, Svenja Gräfin von Reichenbach, and Sara Bernshausen of Deutsche Bank, which named Qureshi its Artist of the Year 2013, aided our initial discussions about the show. I am also indebted to Vinay Chawla of the United States Embassy, Islamabad; Jonathan Ginsburg and Andrea Floyd of Fettman Ginsburg PC; Kishwar Rizvi of Yale University; and Marilyn Wyatt for their excellent diplomacy.

At the Met, no show would blossom on our walls (or floors) without Associate Director for Exhibitions Jennifer Russell; Manager for Special Exhibitions, Gallery Installations, and Design Linda Sylling; and their staff. Christine Coulson in the Director's Office attended to numerous details. Martha Deese and Maria E. Fillas in the Director's Office; Tom Scally and Taylor Miller in Buildings; and Lee White Galvis and Melissa Oliver-Janiak in the Counsel's Office, provided invaluable support and advice. Norie Morimoto contributed an elegant graphic design for the show, for which Pamela T. Barr shaped the text, and conservators Kendra Roth and Shawn Digney-Peer proved willing to experiment with this ephemeral work. Sarah Higby, Lesley Cannady, and Kate Dobie in Development secured financial support and attended to our patrons. Mark Polizzotti, Gwen Roginsky, Peter Antony, Michael Sittenfeld, Jennifer Van Dalsen, and Kamilah Foreman in Editorial enthusiastically initiated this series of Roof Garden publications with this book. I must also thank Sheila Canby, Navina Najat Haidar, and Courtney A. Stewart in Islamic Art. Leonard A. Lauder Chairman of Modern and Contemporary Art Sheena Wagstaff and Director Thomas P. Campbell wholeheartedly supported this project.

Above all, I extend my profound thanks to Imran Qureshi, whose thoughtful ingenuity has resulted in this remarkable installation. To get to this point, he surmounted a variety of hurdles with aplomb, embodying the quiet dignity one finds in his work's simple motifs, unembellished materials, and far-reaching vision.

Ian Alteveer

This catalogue is published in conjunction with "The Roof Garden Commission: Imran Qureshi," on view at The Metropolitan Museum of Art, New York, from May 14 through November 3, 2013.

The exhibition is made possible by

Bloomberg

Additional support is provided by Cynthia Hazen Polsky and Leon B. Polsky.

**Published by
The Metropolitan Museum of Art, New York**
Mark Polizzotti, Publisher and Editor in Chief
Gwen Roginsky, Associate Publisher and General Manager of Publications
Peter Antony, Chief Production Manager
Michael Sittenfeld, Managing Editor
Robert Weisberg, Senior Project Manager

Edited by Kamilah Foreman
Designed by Gina Rossi
Production by Jennifer Van Dalsen
Bibliography by Jean Wagner

Photographs of works in the Metropolitan Museum's collection are by The Photograph Studio, The Metropolitan Museum of Art, unless otherwise noted.

All artworks by Imran Qureshi © Imran Qureshi.

Page 8: photograph by Hassam Rana © Hassam Rana; page 10: © British Library Board/Robana/Art Resource, NY; page 29: photograph by Marcella Sirhandi; page 36: courtesy the artist and Corvi-Mora, London; pages 58–59: photographs by Mathias Schormann

Typeset in Galaxie Polaris and Chronicle
Printed on 100 lb. Phoenix-motion Xenon Matt
Separations by Professional Graphics, Inc., Rockford, Illinois
Printed and bound by Capital Offset, Concord, New Hampshire

Jacket, cover, and page 1: Imran Qureshi, Untitled Installation, 2013. Acrylic. Installation view, "The Roof Garden Commission: Imran Qureshi," The Metropolitan Museum of Art, New York, 2013. Photographs by Hyla Skopitz, The Photograph Studio, The Metropolitan Museum of Art

Frontispiece, page 2: Imran Qureshi with *They Shimmer Still* (2012), Cockatoo Island, "All Our Relations," Biennale of Sydney, 2012. Photograph by Felicity Çelik

The Metropolitan Museum of Art
1000 Fifth Avenue
New York, New York 10028
metmuseum.org

Distributed by
Yale University Press,
New Haven and London
yalebooks.com/art
yalebooks.co.uk

Cataloging-in-Publication Data is available from the Library of Congress.
ISBN 978-1-58839-519-1 (The Metropolitan Museum of Art)
ISBN 978-0-300-19775-4 (Yale University Press)